# hc

the pocket

**Yishan Li**

# hands & feet
## the pocket reference to drawing manga
Yishan Li

Search Press

First published in Great Britain 2010 by
Search Press Limited
Wellwood, North Farm Road,
Tunbridge Wells, Kent TN2 3DR

Copyright © 2010 Axis Publishing Limited

Created and conceived by
Axis Publishing Limited
8c Accommodation Road
London NW11 8ED
www.axispublishing.co.uk

Creative Director: Siân Keogh
Editor: Anna Southgate
Art Director: Sean Keogh
Production: Bili Books

All rights reserved. No part of this book, text, photographs or illustrations may be reproduced or transmitted in any form or by any means by print, photoprint, microfilm, microfiche, photocopier, internet or in any way known or as yet unknown, or stored in a retrieval system, without written permission obtained beforehand from Search Press.

ISBN: 978-1-84448-522-2

The Publishers and author can accept no responsibility for any consequences arising from the information, advice or instructions given in this publication.
Readers are permitted to reproduce any of the items in this book for their personal use, or for the purposes of selling for charity, free of charge and without the prior permission of the Publishers. Any use of the items for commercial purposes is not permitted without the prior permission of the Publishers

# contents

| | | |
|---|---|---|
| Introduction | | 6 |
| materials and equipment | | 10 |
| ■ | hands: bone structure | 20 |
| ■ | basic hand shapes | 24 |
| ■ | hands holding | 46 |
| ■ | hands | 78 |
| ■ | feet | 140 |
| ■ | feet: bone structure | 142 |
| ■ | basic foot shapes | 144 |
| ■ | feet and shoes | 172 |
| Index | | 190 |

# Introduction

Manga has become a popular art form across the globe. Originating in Japan, the term is the Japanese word for 'comic', as it was in Japanese comic strips that such characters were first seen.

### manga style

The huge popularity of manga has much to do with the content of the comic-strip stories. Invariably this involves a moralistic tale of good versus evil, in which good inevitably claims victory. Along the way, characters face challenges and encounter strange beings that look set to obstruct their goals.
What stands out about manga art is the appearance of the 'human' looking characters There is often a great deal of ambiguity here; with

**HANDS & FEET** 7

super-skinny girls and pretty boys making it difficult, sometimes, to determine gender. Although drawn to familiar scale and proportion, manga faces are generally simplified forms, rendered by using the minimum of lines and flat colour. The mouth may be a single line, the nose just a curve in the middle of the face. In most cases the eyes dominate, particularly in younger characters, where they are exaggerated. When it comes to the hair, spiky tresses and

The hand of a young female. There is almost no detail here – the fingernails are suggested by the feintest of lines.

asymmetrical fringes abound, and there are no rules when it comes to colour.

**manga hands and feet**
It is here, perhaps, that the manga style is most representative of the human form. For hands and feet are generally just like those of a human, although often simplified. The hands and feet of the young are smooth and chubby, while those of the old show signs of age – wrinkles and bones visible beneath the skin. The challenge comes in being able to draw hands and feet convincingly and in a wide range of poses, and that is where this book comes in. Step by step, the instructions on the following pages show you how to draw convincing manga hands and feet, –

# HANDS & FEET

from the first rough sketch to finished artwork. You will learn how to draw hands and feet in various positions – from holding a pencil to standing on tiptoe – and from different view points – face on, from the side and from a three-quarter angle. To complete the book are instructions on drawing gloves and footwear that can be adapted to suit every conceivable story line.

Even this mecha hand is based on the human form, and has metal digits with articulated joints.

# materials and equipment

In order to create your own manga art, it is a good idea to invest in a range of materials and equipment. The basics include paper for sketches and finished artworks, pencils and inking pens for drawing, and colour pencils, markers or paints for finishing off. There are also a handful of drawing aids that will help produce more professional results.

**HANDS & FEET** 11

# drawing

Every manga character must start with a pencil sketch – this is essential. You need to build each figure gradually, starting with a structural guide and adding body features, then clothes, in layers. The best way to do this effectively is by using a pencil.

## pencils

You can use a traditional graphite pencil or a mechanical one according to preference. The advantages of the latter are that it comes in different widths and does not need sharpening. Both sorts are available in a range of hard leads (1H to 6H) or soft leads (1B to 6B); the higher the number in each case, the harder or softer the pencil. An HB pencil is halfway between the two ranges and will give you accurate hand-drawn lines. For freer, looser sketches, opt for something softer – say a 2B lead. Some of the sketches in this book are drawn using a blue lead. This is particularly useful if you intend to produce your artworks digitally, as blue does not show up when photocopied or scanned. If you opt for a traditional graphite pencil, you will also need a pencil sharpener.

*An eraser or putty eraser is an essential tool. Use it to remove and correct unwanted lines or to white-out those areas that need highlights. Choose a good-quality eraser that will not smudge your work.*

## HANDS & FEET 13

**FRENCH CURVES**

**STRAIGHT EDGE**

*Drawing aids range from the simple ruler to a host of stencils. Use them to draw perfect straight lines, to get matching wheels on a car, or to shape the curls of a character's hair.*

**CIRCLE GUIDE**

### drawing aids and guides

The tips in this book show you how to draw convincing manga characters from scratch by hand. There may be times, however, when drawing by hand proves a little too difficult. Say your composition features a futuristic city scape; you might want to use a ruler to render the straight edges of the buildings more accurately. The same could be true if you wanted to draw more precise geometric shapes – a true circle for the sun, for example.

# inking and colouring

Once you have drawn your manga character in pencil, you can start to add colour. This is where you can really let your imagination run free. There are numerous art materials available for inking and colouring, and it pays to find out which ones suit you best.

## inking

A good manga character relies on having a crisp, clean, solid black outline, and the best way to achieve this is by using ink. You have two choices here. First is the more traditional technique, using pen and ink. This involves a nib with an ink cartridge, which you mount in a pen holder. The benefit of using this method is that you can vary the thickness of the strokes you draw, depending on how much pressure you apply as you work. You also tend to get a high-quality ink. The alternative to using pen and ink is the felt-tipped drawing pen, which comes in a range of widths. A thin-nibbed pen (0.5mm) is best, but it is also a good idea to have a medium-nibbed pen (0.8mm) for more solid blocks of ink. Whichever option you go for, make sure the ink is quick-drying and/or waterproof so that it does not run or smudge as you work.

*Pen holders and nibs come in different sizes. It is good to have a ready supply of nibs, as they wear down quickly and lose their edge.*

**HANDS & FEET**

*Brush pens are useful for creating flowing lines, often required for colouring hair and clothing.*

*Colour markers can be expensive, so it is worth buying just a handful to start with, and building up your collection over time.*

### colouring

There are various options available to you when it comes to colouring your work. The most popular method is to use marker pens. These are fast-drying and available in very many colours. You can use them to build up layers of colour, which really helps when it comes to creating shading in, say, hair or clothing. You can also use colour pencils and paints very effectively (gouache or watercolour). Colour pencils and watercolours are probably the most effective media for building up areas of tone – say for skin – and also for blending colours here and there. White gouache is very useful for creating highlights, and is best applied with a brush.

# papers

It is difficult to imagine that you will have the perfect idea for a character every time you want to draw a manga scenario. These need to be worked at – not just in terms of appearance – but also in terms of personality. It is a good idea, therefore, to have a sketchbook to hand so that you can try out different ideas. Tracing paper is best for this, as its smooth surface allows you to sketch more freely. You can also erase unwanted lines several times over without tearing the paper. A recommended weight for tracing paper is 90gsm.

Having sketched out a few ideas you will want to start on a proper composition, where you move from pencil outline to inked drawing to finished coloured art. If you are tracing over a sketch you have already made, it is best to use paper that is only slightly opaque, say 60gsm. In order to stop your colours bleeding as you work, it is important that you buy 'marker' or 'layout' paper. Both of these are good at holding colour without it running over your inked lines and blurring the edges. 'Drawing' paper is your best option if you are using just coloured pencils with the inked outline, while watercolour paper is, of course, ideal for painting with watercolour – a heavyweight paper will hold wet paint and colour marker well. You also have a choice of textures here.

*It is always best to allow space around the edge of your composition, to make sure that the illustration will fill the frame.*

## HANDS & FEET 17

20mm

TRIM

20mm

IMAGE AREA
(SAFETY ZONE)

20mm

TRIM SPACE

20mm

# using a computer

The focus of this book is in learning how to draw and colour manga characters by hand. Gradually, by practising the steps over and again you will find that your sketches come easily and the more difficult features, such as hands, feet and eyes, begin to look more convincing. Once that happens, you will be confident enough to expand on the range of characters you draw. You might even begin to compose cartoon strips of your own or, at the very least, draw compositions in which several characters interact with each other – such as a battle scene.

Once you reach this stage, you might find it useful to start using a computer alongside your regular art materials. Used with a software program, like Adobe Photoshop, you can colour scanned-in sketches quickly and easily. You will also have a much wider range of colours to use, and can experiment at will.

*Any home computer can be used for colouring your manga sketches in order to produce finished art.*

*You can input a drawing straight into a computer programme by using a graphics tablet and pen. The tablet plugs into your computer, much like a keyboard or mouse.*

Moving one step further, a computer can save you a lot of time and energy when it comes to producing comic strips. Most software programs enable you to build a picture in layers. This means that you could have a general background layer – say a mountainous landscape – that always stays the same, plus a number of subsequent layers on which you can build your story. For example, you could use one layer for activity that takes place in the sky and another layer for activity that takes place on the ground. This means that you can create numerous frames simply by making changes to one layer, while leaving the others as they are. There is still a lot of work involved, but working this way does save you from having to draw the entire frame from scratch each time.

Of course, following this path means that you must invest in a computer if you don't already have one. You will also need a scanner and the relevant software. All of this can be expensive and it is worth getting your hand-drawn sketches up to a fairly accomplished level before investing too much money.

# bone structure

Manga hands are normally slim, so it helps to know a little bit about the bone structure of the hand.

**HANDS: BONE STRUCTURE**

**ABOVE**
The bones of the hand are made up of three regions: the phalanges, or finger and thumb bones, (shown in red), which form the most flexible and articulate part of the hand; the metacarpals, or knuckles, (shown in green) and the carpals, or wrist bones, (shown in brown).

**BELOW** A good grasp of the bone structure of the hand will help you to draw a realistic outline from which to progress.

## HANDS: BONE STRUCTURE

## bone structure continued

**RIGHT** Each of the four fingers has three phalanges, while the thumb has only two.

## HANDS & FEET  23

**LEFT** You can see from different hand poses, that the phalanges are the bones that change position most frequently.

**RIGHT** On thinner hands, the knuckles are more prominent than on fatter hands. Wrist bones are not evident very often.

## BASIC HAND SHAPES

# age and the hand

**LEFT** Babies' hands are very rounded with short and fat fingers.

**RIGHT** Less elegant than the young woman's hand, this child's hand is slightly chubby with shorter fingers.

## HANDS & FEET 25

**LEFT** A young woman's hand. The hand is slim with long shapely fingers. The skin is soft and smooth.

**RIGHT** The hand of an older person will have plenty of wrinkles around the joints. The knuckles are visible under the skin.

**BASIC HAND SHAPES**

# palm down

Follow these steps to draw the back of the hand with fingers spread. This is one of the easiest hand poses to master.

**1** Start with three or four basic shapes. Use pencil to draw your outlines, and think about the size and proportion of each section of the hand in relation to the next as you work.

**HANDS & FEET** 27

**2** Refine your basic outline, erasing any unwanted lines. Take the different lengths of the fingers into consideration.

▶▶

**BASIC HAND SHAPES**

## palm down continued

**3** Draw very approximate outlines for the fingers, and indicate the point at which they join the palm of the hand with a pencil line.

**HANDS & FEET** 29

4 Divide each finger into separate joints (they have three, while the thumb has two). You may find it helpful to refer to the bone structure on page 20.

**BASIC HAND SHAPES**

## palm down continued

**5** Refine your outlines for the fingers. Notice that they are not straight, but curve slightly at the joints. This is a young woman's hand, so keep your lines to a minimum so that the skin is smooth.

**HANDS & FEET** 31

**6** Make any minor adjustments to the basic outline, such as making the fingertips more shapely.

▶▶

**BASIC HAND SHAPES**

## palm down continued

**7** Add the smaller details: tiny marks to give an indication of the knuckles below the skin, and short lines to show where the fingernails lie.

**HANDS & FEET** 33

**8** Go over the basic outline in ink and erase any unwanted pencil lines. Colour your image, giving it some tone to make it look three-dimensional.

## BASIC HAND SHAPES

# palm up
This is a simple form – the palm facing up with fingers slightly spread.

**1** Using pencil, you can start this drawing with very simple rectangular shapes for the hand and wrist. Draw in the position of the thumb.

**2** Refine your basic outline now, giving more shape to the thumb. Consider the different lengths of the fingers as you work on the rest of the hand.

**HANDS & FEET** | 35

3 Draw the outline of each of the fingers, noting the point at which they join the palm of the hand.

4 Refine your outlines for the fingers. Notice that they are not straight, but curve slightly at the joints.

▶▶

## palm up continued

**BASIC HAND SHAPES**

**5** Divide each finger into separate joints (they have three, while the thumb has two). You may find it helpful to refer to the bone structure on page 20.

**6** Move, now, to the palm of the hand. Draw in the mound that forms at the base of the thumb.

**HANDS & FEET** 37

**7** Draw in the main lines that form the creases in the palm of the hand. This will help to keep it looking three-dimensional when you start to add colour.

**8** Go over the basic outline in ink and erase any unwanted pencil lines. Colour your image, adding darker tones in the creases to suggests shadow.

## BASIC HAND SHAPES

## side view

This is a difficult pose to master, but one that you are likely to use frequently. The key is getting the perspective right.

**1** Start very simply, by drawing the curve made by the back of the hand in profile. Use pencil.

**2** Build on your basic outline, drawing the outer curve of the hand, made by the thumb and fingers when seen from the side.

**HANDS & FEET** 39

3 Draw in each of the fingers. Think carefully about perspective, and how one finger may be partly obscured by its neighbour.

4 When happy with your basic outline, refine the hand, giving more shape to the fingers and thumb. Remember to render the different finger lengths accurately.

▸▸

**BASIC HAND SHAPES**

### side view continued

5. Work on the palm and wrist area, trying to make it look realistic. The bend of the wrist can often look awkward.

6. Finish your basic hand by refining the shapes of the fingers. Make sure they bend elegantly at the joints and round them off at the fingertips.

**HANDS & FEET** 41

**7** Draw in some fingernails. Keep these simple, hinted at using just a couple of basic lines. Remember to consider perspective as you do this.

**8** Go over your basic outline in ink and erase any unwanted pencil lines. Colour your image, adding darker tones to keep it looking three-dimensional.

**BASIC HAND SHAPES**

# fingers splayed

This is a useful hand pose, and one that you may find yourself coming back to time and again.

**1** Using a pencil, draw a very basic shape for the palm of the hand. Add five lines to mark the positions of the fingers and thumb.

**2** Build on your outline, using the finger and thumb lines as a guide. Remember the lengths of the fingers in relation to one another.

## HANDS & FEET 43

3 Erase unwanted pencil lines and refine the outlines of your fingers and thumb.

4 Make any minor adjustments to the basic outline, such as making the fingertips more shapely.

▶▶

**BASIC HAND SHAPES**

## fingers splayed continued

**5** Draw in the main lines that form the creases in the palm of the hand. This will help to keep it looking three-dimensional when you start to add colour.

**6** Divide each finger into separate joints (they have three, while the thumb has two). You may find it helpful to refer to the bone structure on page 20.

## HANDS & FEET 45

**7** Draw in the fingernails. You just see the tips of these, protruding over the ends of the fingers. Note that you see a bit more of the thumbnail.

**8** Go over your basic outline in ink and erase any unwanted pencil lines. Colour your image, adding darker modelling tones to keep it looking realistic.

**HANDS HOLDING**

# holding a book

As you develop your story lines, you will want to draw hands in more complex poses, in particular holding objects.

**1** Draw your basic outline in pencil. It does not matter if your lines overlap at this stage, as it is more important to get the shapes right. Use a picture for reference, if you like.

**2** With the outline of the hand complete, draw in the thumb shape, which will overlap the palm. Concentrate on getting the perspective right.

**HANDS & FEET** 47

3 Now draw in the shape made by the little finger. Most of this will be obscured by the book, but keep it complete for now. Make the book look more three-dimensional.

4 Erase the lines of the hand that are obscured by the book and refine the outline of the hand to make it look more realistic.

▶▶

**HANDS HOLDING**

## holding a book continued

**5** Give the book some pages. This is easily done by drawing in a few lines along the open edges at the side and bottom.

**6** Finalise the outline of the hand, making the thumb and fingertip of the little finger more rounded.

**HANDS & FEET** 49

7 Draw in a few feint lines to suggest the nails on the thumb and little finger. Keep these very simple.

8 Go over the basic outline in ink and erase any unwanted pencil lines. Colour your image, adding darker tones on both the hand and the book to keep them looking three-dimensional.

## holding a pen

Follow these steps for drawing someone holding a pen. If the person is left-handed, simply reverse the hand.

**HANDS HOLDING**

**1** Start by getting the basic shape of the hand right. It is almost like a fist. Draw in rough pencil guides for the thumb and base of the fingers.

**2** Draw very basic shapes for the fingers and thumb. Think about perspective, and how one finger may be partly obscured by its neighbour.

**HANDS & FEET** 51

3. Refine your outline, giving more shape to the fingers and thumb. Think about how the joints of the fingers should look.

4. Work on the thumb, making it a more realistic shape, and rounding it off at the tip.

▶▶

**HANDS HOLDING**

## holding a pen continued

**5** Now draw in your pencil shape. Think about perspective when deciding on the angle. Use a photo for reference, if you like.

**6** Finish your basic shape, slimming down the fingers here and there. Remove any unwanted pencil guidelines.

**HANDS & FEET** 53

**7** Draw in some detail – a few lines on the palm of the hand, and the fingernails. Keep them quite simple.

**8** Go over your basic outline in ink. Colour your image, adding darker tones to keep it looking three-dimensional.

**HANDS HOLDING**

# holding a bottle

This is a useful exercise for drawing a hand when a large part of it is hidden from view.

1. Using a pencil, draw a basic outline of both the hand and the bottle, drawing them both as complete objects.

2. Refine the shape of the bottle, to give it a waist, and erase any lines that are obscured by the hand as it wraps around the glass.

**HANDS & FEET** 55

**3** Work on the hand, now, making it a more realistic shape and drawing in each of the individual fingers. Try to keep it looking natural.

**4** Refine the shape of the thumb and round off the fingertips. Add a bottletop to the bottle.

▶▶

**HANDS HOLDING**

### holding a bottle continued

5 Draw some more detail on the bottle, starting with the label. This is a bottle of cola, so you may want to use the real thing for reference.

6 Draw in the depressions on the glass. Notice how they are not complete towards the top of the bottle.

**HANDS & FEET** 57

**7** Finish your hand, adding a few lines to suggest the finger- and thumbnails.

**8** Go over the basic outline in ink. Colour your image, adding darker tones and highlights to keep it looking three-dimensional.

**HANDS HOLDING**

# holding a ball

For this pose, the hand is splayed and tense. You can adapt it to show hands poised for throwing and catching a ball.

**1** Start by drawing a ball in pencil. You could use a stencil for this. Now draw a very basic outline of the spread hand as it supports the ball to the rear.

**HANDS & FEET** 59

**2** Build on the basic outline, drawing in the fingers that support the ball to the front. You can use a photo for reference.

▶▶

**HANDS HOLDING**

## holding a ball continued

**3** Refine the shapes of the fingers and thumb. Pay attention to the way that they obscure one another in places. Note the tension in the joints.

**HANDS & FEET** 61

**4** Erase those lines of the ball that are obscured by the fingers and thumb.

▶▶

**HANDS HOLDING**

## holding a ball continued

**5** Add some creases to the palm of the hand. Give the ball some form. This is a basketball – start to draw in the lines of stitching. Think about the perspective carefully as you do this.

**HANDS & FEET** 63

**6** Draw in the remaining lines of stitching. Take care where a line disappears behind a finger.

**HANDS HOLDING**

## holding a ball continued

**7** Finalise your pencil drawing by adding simple lines to suggest any visible fingernails.

## HANDS & FEET 65

**8** Go over the basic outline in ink and erase any unwanted pencil lines. Colour up your image, adding darker tones in the shaded areas.

**HANDS HOLDING**

# holding a flower

This is a similar pose to the hand holding a pen (see page 50) and can be used whenever the fingers are pinched.

1 Using a pencil, draw the basic hand shape. It is important to get the angle right. Use your own hand as a reference, if it helps.

2 Draw in the basic outline of the thumb. It should slightly overlap the top finger.

**HANDS & FEET** 67

3 Continue to draw in the outline of the top finger. Think about how the joints work. Draw in the basic shape of the fingertips protruding below the line of the thumb.

4 Add more detail, drawing in the lines that make up the remaining fingers seen behind the thumb.

▶▶

**HANDS HOLDING**

## holding a flower continued

**5** Begin to give the hand a more natural shape. Define the curve of the thumb as it meets the wrist and give the digits rounded tips.

**6** Work on the fingers, slimming them down a bit and shaping the fingertips.

**HANDS & FEET** 69

**7** Now you can draw in the flower. This is a simple rose, but you could use anything. Take care to get the perspective right. Draw in the visible fingernails.

**8** Go over the basic outline in ink and erase any unwanted pencil lines. Colour up your image, adding darker tones in the shaded areas.

## holding a bowl

This pose can be used for holding any large item. The palm is open in much the same way as for holding scissors (page 90).

**HANDS HOLDING**

1. Draw a basic outline in pencil. It is easiest if you start with the bowl. This will help to get the angle of the hand right.

2. Draw in the outline of the thumb holding the top of the bowl. Draw in the crease made where the fingers join the palm of the hand. Think about perspective here.

## HANDS & FEET 71

3. Make the bowl look more three-dimensional by drawing a shallow ellipse for the top, and a line to mark the bottom of the bowl's rim.

4. Draw in the fingers as they curve around and support the bottom of the bowl. Note that not all of the fingers are visible, and that they need to be bent at the joints.

▶▶

**HANDS HOLDING**

## holding a bowl continued

**5** Give more shape to the palm of the hand. Draw in a feint crease to show the stretch of the thumb, and add a few lines to separate the fingers.

**6** Build on the detail, by adding a few more creases to the palm of the hand. Work a bit more on the fingers, defining the separate joints.

**HANDS & FEET** 73

**7** Finish your basic drawing. Round off the fingertips and give the fingers and thumb the indication of some nails.

**8** Go over the basic outline in ink and erase any unwanted pencil lines. Colour up your image, adding darker tones in the shaded areas. Give the bowl some tone to make it three-dimensional.

**HANDS HOLDING**

# holding a sword

Many manga stories involve one-on-one battles and the sword is a popular weapon of choice.

**1** Draw the sword grip in pencil. Getting the perspective right is key. Now draw in a rough outline for the hands. Note that one is palm up and one palm down.

**2** Working on the right (palm up) hand, draw in the thumb overlapping the bent fingers. This is similar to drawing the fist (see pages 78–81).

**HANDS & FEET** 75

3 Now draw in rough guidelines for the fingers on each hand. You will also be able to see the thumb tip of the left hand – draw this in, too.

4 Go back to the right hand, and begin to shape the fingers more. Think about how the knuckles should look, and round off the tips. Draw in the creases made in the thumb as it bends.

**HANDS HOLDING**

## holding a sword continued

**5** Return to the left hand. Give it a more natural grasp of the sword by raising the index finger slightly. Draw in a crease where it bends.

**6** Work some more detail into the sword, such as the metal casing that grasps the blade.

**HANDS & FEET** 77

**7** Finish your hands by adding a few lines to suggest the fingernails.

**8** Go over the outline in ink and erase any unwanted pencil lines. Colour up your image, adding darker tones in the shaded areas.

**HANDS**

## making a fist
The fist is a very useful pose to be able to draw and can be used for various different situations in a story line.

**1** Start with the basic outline, in pencil. You need a tilted rectangular shape. Use your own hand for reference.

**2** Draw in the approximate position of the knuckles as they cluster in the palm of the hand.

## HANDS & FEET 79

**3** Now draw in the thumb, roughly, as it overlaps the knuckles. Think about how it is jointed in three sections.

**4** Divide the knuckle area into four, showing where each of the fingers should go. You do not have to be precise at this stage.

▶▶

**HANDS**

## making a fist continued

5 Start to give shape to the fingers. Define each one across the top of the knuckles, first.

6 Then draw in the bottom of the knuckles. As you work, bear in mind the relative sizes of all the fingers.

**HANDS & FEET**

**7** Refine the shape of the wrist where it meets the palm of the hand, and add some final details – a couple of creases in the palm and the fingernails.

**8** Go over the basic outline in ink. Colour your image, adding darker tones in the palm of the hand, where the skin lies in shadow.

## pointing a finger

This is another useful pose, and is easily adapted for raising one or more fingers – to indicate numbers, for example.

**HANDS**

**1** Decide on the direction in which your finger is pointing and draw this line first, using pencil. Then draw the fist and wrist.

**2** Perspective is key here. Start to draw in the knuckles of the bent fingers and thumb.

**HANDS & FEET** 83

**3** Start to give shape to the pointing finger and thumb. Get the position of the thumb right as it overlaps the other fingers.

**4** Refine the shapes of the bent fingers, drawing in the knuckles at top and bottom.

▶▶

## pointing a finger continued

**5** Finish up on the shapes of the fingers. Make them a little slimmer and give them nice, rounded fingertips.

**6** Work a little more on the thumb, refining its shape, and draw in the thumbnail.

**HANDS & FEET** 85

**7** Draw the fingernails – simple outlines are enough – and don't forget the one on the pointing finger, seen in reverse.

**8** Go over the basic outline in ink. Colour your image, adding darker tones in the shaded areas.

## HANDS

# opening a door

It is not always easy to draw hands realistically, particularly when holding something. Perspective is often key.

**1** Using a pencil, draw the basic shapes made by the hand and doorknob. You need to get the perspective right early on. Use your own hand for reference, if you like.

**2** Make the doorknob look three-dimensional. Begin to refine the shape of the hand, thinking about how the fingers and thumb wrap around the doorknob.

## HANDS & FEET 87

**3** Build on the detail of the doorknob, then start work on the two fingers that are partially hidden behind it. Round off the knuckles.

**4** Refine the shapes of the other two fingers, now. Make them slimmer and give them rounded fingertips.

▶▶

**HANDS**

## opening a door continued

**5** Refine the shape of the thumb. Think about where the joints are and give it some knuckles.

**6** Add more detail to the doorknob; draw in the keyhole. Draw a few lines to show creases in the palm of the hand.

## HANDS & FEET

**7** Finish off your drawing. Refine any shapes and add the finger- and thumbnails.

**8** Go over the basic outline in ink and erase any unwanted pencil lines. Colour up your image, adding darker tones in the shaded areas, and some highlights to enhance the modelling.

## using scissors

This is a difficult pose to master. It can be adapted for characters holding weapons, depending on your story line.

**1** Concentrate on getting the shape of the hand right. Think about the line of the thumb and where the base of the fingers meet the palm. Use pencil.

**2** Refine your hand, drawing in the complete thumb and the shape made by the bent fingers.

## HANDS & FEET

**3** Start to draw in the scissors. Keep it one-dimensional for now, focusing of the basic shape and perspective.

**4** Consider how the handles of the scissors loop around the thumb and first two fingers. Draw in the scissor blades.

▶▶

# using scissors continued

**5** Draw in each of the four fingers, remembering their relative lengths. Give some shape to the knuckles.

**6** Finalise the scissors now, adding any last details, such as the pivot. Draw in a crease at the base of the fingers.

**HANDS & FEET** 93

**7** Finish off the hand, adding more creases to the palm and a few lines to suggest the thumb- and fingernails.

**8** Go over the basic outline in ink and erase any unwanted pencil lines. Colour up your image, adding darker tones in the shaded areas.

## thumbs up

This is a really popular hand gesture, and one that is quite easy to draw. It is quite similar to the fist on page 78.

**1** Start as you did for making a fist, but with the hand turned on its side. Draw in the line of the raised thumb. Use pencil.

**2** Draw in a very simple line to suggest the end of the knuckles where they fit in the palm of the hand.

## HANDS & FEET

**3** Finish the outline of the thumb, giving it a nice curve for the top joint. Draw in the shape made by the bent fingers.

**4** Divide the finger section into four parts to establish the fingers, taking into account their relative sizes. Keep it simple for now.

## thumbs up continued

**HANDS**

**5** Draw in a line for the top joints of the fingers. You need to think about perspective here, as the top joints of the fingers are foreshortened.

**6** Refine your lines, giving more shape to the fingers. Give them more pronounced knuckles and fingertips.

**HANDS & FEET** 97

7. Add the final details. Draw in a few creases in the palm of the hand and finish the fingers and thumb of with some nails.

8. Go over the basic outline in ink and erase any unwanted pencil lines. Colour up your image, adding darker tones in the shaded areas.

## okay gesture

The okay gesture is another manga favourite. It is similar to the hand holding a pen or a flower (see pages 50 and 66).

**1** Using pencil, start by drawing the shape made by the index finger and thumb as they join together. You just need to get the outline for now.

**2** With that done, you can draw in the lines of the remaining fingers as they are raised in the air. Just mark their positions.

**HANDS & FEET**

**3** Refine the 'okay' shape made by the index finger and thumb. Use your own hand for reference and notice how the thumb overlaps the finger.

**4** Draw in the outlines of the remaining fingers, taking care to get the positions of the joints right. Remember the relative lengths of the fingers, too.

**HANDS**

## okay gesture continued

**5** Refine the shapes of the thumb and index finger. Give the knuckles more definition and round off the finger- and thumb tip.

**6** Round off the tips of the other three fingers, smooth the outline to give them a more natural form.

**HANDS & FEET** 101

**7** Finish your drawing by adding lines to suggest the fingernails. Add a crease to show the stretch at the base of the thumb.

**8** Go over the basic outline in ink and erase any unwanted pencil lines. Colour up your image, adding darker tones in the shaded areas.

## victory sign

This pose is similar to the pointing finger on pages 82–85. It simply has a different orientation and two fingers not one.

**2** Draw in the thumb as it overlaps the palm of the hand. Draw lines to suggest the fingers: two raised in the air and two bent forward.

**1** Draw a basic outline using pencil. For now, just draw in a rough fist shape and the line of the wrist below.

## HANDS & FEET 103

**4** Refine the shapes of the two bent fingers, giving them proper knuckles and fingertips. Make the palm of the hand a more natural shape.

**3** Draw in a proper outline for the raised fingers (remembering their relative lengths), and a rougher outline for those that are bent forward.

▶▶

## victory sign continued

**5** Finish your general outline, rounding off the fingertips, and giving more shape to the knuckles of the bent fingers.

**6** Draw in a couple of feint lines to show creases in the palm of the hand. Add creases for the joints of the raised fingers.

## HANDS & FEET 105

**8** Go over the basic outline in ink and erase any unwanted pencil lines. Colour up your image, adding darker tones in the shaded areas.

**7** Draw in the fingernails on the two bent fingers and on the thumb. Keep them simple.

## HANDS

# hands in prayer

Clasped hands are difficult to draw, as the fingers and thumbs need to overlap one another convincingly.

**1** Begin with a very basic shape for the left hand. Decide on the angle of the hands in relation to the wrist. Draw the outline made by the knuckles. Use pencil.

**2** Now draw in the basic shape made by the thumbs. Remember that these are bent, too. Add a simple line to suggest the wrist of the right hand.

## HANDS & FEET 107

**3** Draw each of the thumbs, taking care to show how one overlaps the other. Give more definition to the outline of each of the knuckles.

**4** Draw in the fingers of the right hand as they come from behind to clasp those of the left hand. Remember the relative lengths of the fingers.

▶▶

## hands in prayer continued

**5** Refine your lines, making the fingers slimmer and smoother with nice rounded fingertips.

**6** Give a bit more shape to the wrist on the left hand. Draw in the wrist bone as it sticks out.

## HANDS & FEET

**7** Finish your drawing by giving the visible fingers and thumbs nails. Keep your lines simple.

**8** Go over the basic outline in ink and erase any unwanted pencil lines. Colour up your image, adding darker tones in the shaded areas.

## HANDS

# hands on cheeks

It can be hard to get this pose looking natural. The hands are closed, but are looser and more relaxed than a fist.

**1** Start with a very basic outline for the face and draw the positions of the hands. Use pencil. It does not matter if your lines overlap, the shapes are more important at this stage.

**2** Draw in the position of the facial features. Keep these simple for now. Add an ear and eyebrows.

## HANDS & FEET

**3** Start to draw in some detail on the hands: mark the rough position of the fingers as they curl in towards the palm of the hand. Start to shape the fingers of the left hand. Draw in the left thumb.

**4** Continue to work on the fingers of both hands. Note that not all of them are visible. Take care to get their positions right as one obscures the next. Draw in some more detail on the face.

▶▶

## hands on cheeks continued

**HANDS**

**5** Draw a rough outline for the girl's hair. In this example, it fades out of view. Keep your lines simple, you just need to get the general shape.

**6** Return to the hands, refining your shapes to make the fingers look more realistic. Slim them down and give them nice rounded tips.

## HANDS & FEET

**7** Draw in a few lines to suggest the fingernails, where visible – your drawing is complete.

**8** Go over the outline in ink and erase any unwanted pencil lines. Colour up your image, adding darker tones in the shaded areas.

## HANDS

## face in hands

The hands here are open, but also quite relaxed. The pose could also be used to express shock or fear.

**1** Start with a very basic outline of the face and draw the positions of the hands. Use pencil. Note that this is a three-quarter view and think about the perspective.

**2** Mark in a few useful guidelines. For example, to help position the eyes and the line at which the fingers should start. These will help to get your proportions right.

## HANDS & FEET

**3** Start to draw the fingers. These should reach up to the eyes, but should not cover them. Keep them fairly relaxed as they cup around the nose and mouth. Overlap one or two for a more realistic pose.

**4** Build some detail into the face – draw in the eyebrows and the eyes. Remember that the eyes need to look sad and so should be lowered. Give more shape to the fingers.

**HANDS**

## face in hands continued

**5** Draw in an outline for the girl's hair, adding a few extra lines here and there for soft curls.

**6** Having established the shape of the hair, and how it falls over the shoulders, you can erase the pencil guidelines for the girl's neck and ear.

## HANDS & FEET 117

**7** Finish your drawing. Add the final touches to the eyes, such as filling out the eyelids. Draw in a few lines for the fingernails.

**8** Go over the outline in ink and erase any unwanted pencil lines. Colour up your image, adding darker tones in the shaded areas.

## HANDS

# hand in a glove

This is a heavy style of glove for wearing in cold weather or for working in an industrial environment.

**1** Draw a basic outline in pencil. The glove is made from a thick material, so your shape should be quite chunky to reflect this.

**2** Mark the points at which the fingers meet the palm of the hand, and the palm meets the wrist, just as you would for drawing a bare hand.

## HANDS & FEET 119

**3** Use your guide to give more shape to the glove, drawing in the fingers, and elasticated wrist. Add a few creases to give an indication of the hand inside the glove.

**4** Go over the outline in ink and erase any unwanted pencil lines. Colour up your image, adding tone to make it look three-dimensional.

## hand in a baseball glove

The baseball glove is a padded form, sculpted to fit a hand ready to catch a ball.

**1** Draw a basic outline of the glove, using pencil. Think about the point of view, and consider the perspective carefully.

**2** Start to add some detail. Draw in each of the fingers, bearing in mind their relative lengths, and add some of the piped details at the base of the glove near the wrist.

**HANDS & FEET** 121

**3** Finish the drawing, adding all the surface decoration on the glove, such as the leather stitching.

**4** Go over the outline in ink and erase any unwanted pencil lines. Colour up your image, adding tone to make it look three-dimensional.

**HANDS**

# hand in a long black glove
Usually worn by a woman, gloves like this tend to be skin tight. All of the features of the hand within are evident.

**1** Draw an outline, as you would for capturing the pose without the glove. This hand holds a cigarette, draw in a line to suggest this. It is a very relaxed pose.

**2** Draw in the fingers, keep them loose and relaxed looking. Shape them, making them long, slim and elegant.

## HANDS & FEET

**3** Now add the details that suggest the glove. Draw in a seam running down each finger and all the way down the arm. Add a few lines to give the glove some wrinkles where the fabric bunches.

**4** Go over the outline in ink and erase any unwanted pencil lines. Colour up your image, adding highlights where the shiny fabric catches the light, and some darker areas for the shadow.

## hand with jewellery

This is a very relaxed pose. The arm dangles at the characters side, with her jewellery tumbling down to the wrist.

**1** Draw in your outline, in pencil, making sure you get the perspective right. Mark the line at which the fingers meet the back of the hand.

HANDS

**HANDS & FEET** 125

2 Draw a rough outline of the ring on the index finger. With a few simple lines, try to capture the way in which the bracelets and bangles overlap each other at the wrist.

▶▶

## hand with jewellery continued

HANDS

3 Build up the detail, making each bracelet different from the next, and filling out the stone in the ring. Draw in the fingernails.

**HANDS & FEET** 127

4. Go over the outline in ink and erase any unwanted pencil lines. Colour up your image, adding tone to make it look three-dimensional.

## child's hand

Children's and chibis' hands are generally less slim or elegant than those of an adult, as they are still developing.

**1** This is a simple pose, with just the fingers visible. Start with a pencil outline, capturing the bend in the wrist and general shape made by the fingers.

**2** Draw in each of the fingers, bearing in mind their relative lengths. This example has the little finger slightly detached from the rest, for a more natural look.

**HANDS & FEET** 129

**3** Shape the fingers nicely, remembering to keep them fuller. Add a few lines to suggest the knuckles beneath the skin and the fingernails.

**4** Go over the outline in ink and erase any unwanted pencil lines. Colour up your image, adding tone to make it look three-dimensional.

## HANDS

# child's hand: fingers splayed

This is similar to the basic hand on pages 26–33. The difference here is that the fingers are shorter and wider.

**1** Use pencil to draw an outline of the hand and arm and fingers as they stretch downwards. Get the perspective right.

**2** Draw each of the digits, bearing in mind their relative lengths. Keep them short and fat.

**HANDS & FEET** 131

**3** Give more shape to the hands, smoothing the lines and giving the digits nice rounded tips and nails.

**4** Go over the outline in ink and erase any pencil. Colour the image, adding tone to make it look three-dimensional.

# child's hand: fingers relaxed

While the hand on the previous spread was quite toddler-like, this is the hand of a slightly older child.

**1** This is quite a relaxed pose. Using pencil, draw a basic outline to get the shape of the hand right. Think about the positions of the fingers.

**2** Draw in each of the fingers, taking care where one overlaps another. Make them a little thinner and longer than you would for a toddler.

## HANDS & FEET

**3** Refine the shapes of the fingers, rounding off the fingertips. Draw a few lines to suggest the fingernails.

**4** Go over the outline in ink and erase any unwanted pencil lines. Colour up your image, adding tone to make it look three-dimensional.

## HANDS

# mecha hand: pointing

This basis of the mecha pointing hand is the same at that for the human version on pages 82–85.

**1** Using pencil, draw a basic outline of a pointing hand. The mecha version is more square than the human version, but has the same proportions.

**2** Draw each of the individual fingers and draw outlines of the metal plates from which the hand is made.

## HANDS & FEET 135

3 Continue to work on the metal elements, adding pivots to show how the joints articulate.

4 Go over the outline in ink and erase any unwanted pencil lines. Colour your image, adding highlights to show where the metal catches the light.

# mecha hand: clenched

This is similar to the human clenched fist on pages 78–81, although much squarer in form and with just three fingers.

**1** Start with the basic outline of the clenched fist, drawing the thumb and the shape made by three fingers.

**2** Give shape to the three fingers, Notice that all four digits are exactly the same size and shape.

**HANDS & FEET** 137

3 Finish your drawing, adding details that show how the mechanism works. Give the fingers nails, if you like.

4 Go over the outline in ink and erase any pencil lines. Colour your image, adding highlights to show where it catches the light.

HANDS

# GALLERY

**ABOVE** A young male hand, bent at the wrist and flopping forwards with limp fingers.

**BELOW** The relaxed hand of a young woman. The skin is smooth and the fingers long and slim.

# HANDS & FEET

**RIGHT** A woman's hand, held in a loose fist.

**LEFT** A woman's hand, held aloft, with gently gesturing fingers.

**RIGHT** The hand of a young man, fingers poised as if about to pick something up.

## feet

Drawing bare feet is not that different from drawing hands. The foot is not as flexible or dexterous as the hand, but some of the positions are similar and can be drawn using the same principles. Feet tend to be covered more often than not, and so it helps to be able to draw them wearing a range of footwear, from flip-flops to trainers.

**HANDS & FEET** 141

**FEET: BONE STRUCTURE**

# bone structure

To help you draw feet in a number of different poses, it helps to know something about bone structure.

Like the hand (see pages 20–21), the bones of the foot are made up of three regions: the phalanges, or toes; the metatarsals, which make up the mid-section of the foot; and the tarsals, which form the heel and ankle.

**HANDS & FEET** 143

Seeing how the bones relate to one another when seen in profile, will help you to draw the foot more accurately.

Knowing the approximate positions of the various joints in the foot will help you to draw the foot in a wider range of positions.

## BASIC FOOT SHAPES

# age and the foot

Depending on the age of a person, his or her feet take on a number of different characteristics.

**ABOVE** Babies' feet are relatively undeveloped and so tend to be quite chubby with short, fat toes.

**ABOVE** More developed than a baby's foot, the foot of a child is still not terribly lean. It has a smooth outline.

## HANDS & FEET 145

**LEFT** A young woman's foot. The foot is slim with long shapely toes. The skin is soft and smooth, but there is a hint of the bone structure.

**RIGHT** The foot of an older person will have plenty of wrinkles around the joints. The bones are visible under the skin.

## BASIC FOOT SHAPES

# basic foot

Follow these steps to draw a basic foot viewed from above. This is one of the easiest foot poses to master.

**2** Draw an approximate line to show where the toes join the rest of the foot.

**1** Start with just an outline. Use pencil to draw a rough foot shape, thinking about the way it tapers at the toe end, and the position of the ankle joint. Think also about proportion.

## HANDS & FEET 147

**4** Start to give the toes some shape, beginning with the big toe. Look at your own toes to get the shape right.

**3** Draw approximate outlines for the toes. Bear in mind their relative sizes. The big toe is by far the widest, for example, but usually shorter than the one next to it.

▶▶

## basic foot continued

**BASIC FOOT SHAPES**

**6** Work on the shape of the foot, and pay particular attention to the way in which it joins the lower leg. Draw in the ankle bone.

**5** Finish the basic outline of the toes. Note how the big toe often rests a little detached, while the others nestle against each other closely.

## HANDS & FEET 149

**8** Go over the basic outline in ink and erase any unwanted pencil lines. Colour your image, giving it some tone to make it look three-dimensional.

**7** Add the smaller details: tiny marks to show where the toes join the rest of the foot, and simple shapes for the toenails.

BASIC FOOT SHAPES

# basic foot: flexed

It helps to have an idea of the bone structure on pages 142–143) to show how the foot flexes.

**1** Draw the basic outline of the foot. Try to keep the line smooth and fluid. Think about perspective.

**2** Draw in a line to show where the toes meet the rest of the foot. The foot should flex just behind this line.

**HANDS & FEET** 151

3 Draw in outlines for each of the toes. Draw a simple line to suggest the ankle bone.

4 Give more shape to the toes. Smooth out the line made by the sole of the foot as it stretches from the little toe to the heel of the foot.

▶▶

**BASIC FOOT SHAPES**

## basic foot: flexed continued

**5** Refine the shapes of the toes, giving them nicely rounded tips.

**6** Once you are satisfied with the outline of the foot, erase any unwanted pencil lines that may confuse the drawing later.

**HANDS & FEET** 153

**7** Finish your drawing by adding some feint lines to suggest the toenails.

**8** Go over the basic outline in ink and erase any unwanted pencil lines. Colour your image, giving it some tone to make it look three-dimensional.

# basic foot: side view

It can be difficult to draw the foot from the side, particularly where it joins the leg. It is a useful pose to master, however.

**1** Start very simply, by drawing the outline of the foot seen from the side while flat on the floor. Use pencil. Try to capture the shape accurately.

**2** Give more shape to your basic outline, smoothing the curves at the heel and toe ends.

BASIC FOOT SHAPES

**HANDS & FEET** 155

3 Draw in a guideline to show where the toes meet the rest of the foot. Draw in the ankle bone. Keep it simple.

4 Divide the front section into separate toes, bearing in mind their varying proportions.

**BASIC FOOT SHAPES**

## basic foot: side view continued

**5** Round off the ends of the toes neatly. Notice how the big toe tends to stick up slightly more than the others.

**6** Give a little more emphasis to the downward curve of the smaller toes. Extend the lines of the toes where they join the rest of the foot.

**HANDS & FEET** 157

**7** Your drawing is almost complete. Finish off by adding some feint lines to suggest the toenails.

**8** Go over the basic outline in ink and erase any unwanted pencil lines. Colour your image, giving it some tone to make it look three-dimensional.

## basic foot: on tiptoes

This is similar to the flexed foot on pages 150–153. Here, the line of the foot is almost vertical.

**BASIC FOOT SHAPES**

**1** Start very simply, by drawing the outline of the foot seen from the side while standing on tiptoes. Use pencil. Try to capture the shape accurately.

**2** Give more shape to your basic outline: make the arch of the foot more pronounced and smooth the curves at the heel and toe ends.

**HANDS & FEET** 159

3 Draw in the ankle bone, and draw a line to show where the toes should meet the rest of the foot. Think about the perspective.

4 Draw in the toes. Since this is a side view, only big toe is seen whole, while the remaining toes are mostly hidden from view.

▶▶

## basic foot: on tiptoes continued

**BASIC FOOT SHAPES**

**5** Give a little more shape to the toes, raising the line of those that are obscured. Round off the ends of the toes neatly.

**6** Refine your outline, drawing in the top of a third visible toe. Remember that perspective will make this seem closer to the neighbouring toe.

**HANDS & FEET 161**

**7** Finish the drawing by indicating a toenail on the big toe.

**8** Go over the basic outline in ink and erase any unwanted pencil lines. Colour your image, giving it some tone to make it look three-dimensional.

# basic foot: heel down

This is a useful pose for a number of situations, from sitting with a crossed leg to walking.

**BASIC FOOT SHAPES**

1 Start by drawing the outline of the foot seen from the side while stepping on the heel. Use pencil. Try to capture the shape in a few lines.

2 Give more shape to the basic outline, smoothing the curves at the heel and toe ends. Draw the outline of the big toe.

## HANDS & FEET    163

**3** Draw a line to show where the toes should meet the rest of the foot. Draw in the ankle bone.

**4** Draw in the toes. All of them are visible, but you need to think about perspective, as they are seen from the side.

▶▶

**BASIC FOOT SHAPES**

## basic foot: heel down continued

**5** Give a little more shape to the toes, raising the line of those that are obscured. Round off the ends of the toes neatly.

**6** Refine your outline, drawing in the top of a third visible toe. Remember that perspective will make this seem closer to the neighbouring toe.

**HANDS & FEET** 165

**7** Finish your drawing by sketching in a toenail on all the toes.

**8** Go over the basic outline in ink and erase any unwanted pencil lines. Colour your image, giving it some tone to make it look three-dimensional.

## BASIC FOOT SHAPES

# basic foot: walking

This pose is somewhere between the flexed foot and the foot on tiptoes (see pages 150–153 and 158–161).

1 Use pencil to draw the outline of the foot seen from the side while walking. Use just a few lines to get the basic shape.

2 Draw a feint line to show where the toes should meet the rest of the foot. Think about the perspective.

## HANDS & FEET 167

3 Draw in the ankle bone. Make your outline generally smoother, giving the heel of the foot a pronounced curve.

4 Draw in the toes. All of them are visible, but you need to think about perspective, as they are seen slightly from the top and the side.

▶▶

**BASIC FOOT SHAPES**

## basic foot walking continued

**5** Improve on the shapes of the toes, bearing in mind their relative shapes and sizes. Give them nice rounded tips.

**6** Refine the shapes of the toes until you are happy with them. Here, the toes have been slimmed down slightly.

## HANDS & FEET 169

**7** Your drawing is almost complete. Finish off by adding some feint lines to suggest the toenails.

**8** Go over the basic outline in ink and erase any unwanted pencil lines. Colour your image, giving it some tone to make it look three-dimensional.

# GALLERY

**BASIC FOOT SHAPES**

**RIGHT** The smooth sole of a youthful foot, seen from below. Gaps between the toes are often more visible from this angle.

**LEFT** A side view of a foot, with just the hint of the toes helping to make it look three-dimensional.

**HANDS & FEET** 171

**LEFT** A right foot of a young person or child. The toes have less shape than they usually do in an adult.

**RIGHT** A flexed left foot. It is often difficult to draw the ankle convincingly in this position.

## FEET & SHOES

## flip-flop

The flip-flop is a very rudimentary form of footwear, that leaves much of the foot visible.

**1** Use basic shapes to draw an outline for the foot and lower leg. These can be very simple indeed. The idea is to get the right perspective.

**2** Draw the outline of the flip-flop around the outline of the foot. From this perspective, only the near side of the flip-flop is visible. Draw a line to mark where the toes meet the rest of the foot.

## HANDS & FEET

**3** Use the line just drawn to draw in the outline of the flip-flop straps. Draw in the sole of the shoe to give it some form.

**4** Start to draw lines for the toes. The big toe should be one side of the straps, and the remaining toes the other side.

▶▶

**FEET & SHOES**

## flip-flop continued

**5** Draw in the flip-flop straps. Consider the perspective as you do this, and the way in which the far strap disappears from view behind the foot.

**6** Start to develop the shape of the foot. Give the toes nice rounded tips and smooth out the line of the heel.

**HANDS & FEET** 175

**7** Finish the drawing off. Draw in the ankle bone and add the toenails.

**8** Go over the basic outline in ink and erase any unwanted pencil lines. Colour your image, giving it some tone to make it look three-dimensional.

## trainers

Trainers are a popular choice for manga characters, particularly for children and teenagers.

**FEET & SHOES**

1. Start with an outline of the foot, using pencil. This is from the three-quarter view. Your shape can be very basic.

2. Draw in the outline of the trainer. You need to think about perspective, but also the size of the shoe in relation to the foot. Allow some room for the sole of the shoe.

## HANDS & FEET

**3** Start to give the shoe more shape at the ankle, and draw in the line of the sole. This will help to make it more convincing.

**4** Develop the shoe further, giving more definition to the sole and marking out the position of the laces.

## trainers continued

**FEET & SHOES**

**5** Add rough outlines for the laces and start to draw in the surface decoration.

**6** Complete the lace and surface decoration – this will really help to make the trainer look three-dimensional. Give the sole of the shoe a textured contour.

## HANDS & FEET 179

**7** Finish your drawing, adding those final details to make it real. Draw in a sock and mark the lines of stitching on the surface of the trainer.

**8** Go over the basic outline in ink and erase any unwanted pencil lines. Colour your image, giving it some tone and a few highlights to make it look more realistic.

## FEET & SHOES

## formal shoe

This is a good style to master for the more mature adult characters in your story lines.

**1** Start with an outline of the foot, using pencil. Your shape can be very basic. This is from the three-quarter view.

**2** Draw in the outline of the shoe, allowing some room for the sole of the shoe. Remember to think about perspective, and the size of the shoe in relation to the foot.

## HANDS & FEET

**3** Refine the shape of your shoe, and draw in the line of the sole. Since this is a formal shoe, it can have a low heel.

**4** Build on the design of the shoe to make it look more three-dimensional. This version has a simple leather upper.

▶▶

## formal shoe continued

**FEET & SHOES**

**5** This shoe has a strap. Draw in the approximate position, bearing in mind the perspective of the drawing.

**6** Complete the surface decoration. Draw in the whole strap and the line of the heel. Add a sock and draw in the ankle bone.

**HANDS & FEET** 183

**7** Finish your drawing. Mark the lines of stitching on the surface of the shoe and give the strap a buckle.

**8** Go over the basic outline in ink and erase any unwanted pencil lines. Colour your image, giving it some tone and a few highlights to make it look three-dimensional.

## FEET & SHOES

# military style boot

This is useful for military or industrial characters and can be adapted to fit a wide range of styles and purposes.

**1** Start with an outline of the foot, using pencil. This is from the three-quarter view, so think about perspective carefully.

**2** Draw in the outline of the boot. Think about the size of the boot in relation to the foot, and how far up the leg it should go. Allow room for a chunky sole.

## HANDS & FEET

**3** Start to give the boot more shape. Draw in the line of the sole. Work on the design of the boot, drawing in the tongue, for example.

**4** Add rough outlines for the boot laces and start to draw in the surface decoration. Give the boot a textured sole.

▶▶

## military style boot continued

**5** Continue to build on the surface decoration to make the boot look more padded.

**6** Complete the laces, taking care where they cross over one another.

## HANDS & FEET 187

**7** Finish your drawing, adding those final details to make it real. Mark the lines of stitching on the surface of the boot.

**8** Go over the basic outline in ink and erase any unwanted pencil lines. Colour your image, giving it some tone and a few highlights to make it look three-dimensional.

# GALLERY

**FEET & SHOES**

**LEFT** A woman's high-heeled boot. Notice how the boot is skin-tight, following the form of the foot and leg closely.

**RIGHT** A woman's shoe with wedge heel, drawn using the basic flexed foot as the starting point (see pages 150–153)

**HANDS & FEET** 189

**LEFT** A youth's trainer, drawn using the basic foot: heel down as a model for getting it to look more convincing (see pages 162–165).

**RIGHT** A foot wearing a trainer, seen from the front. The success of this angle relies on getting the perspective right.

**LEFT** A woman's high-heeled stiletto, seen from the three-quarter rear view. This has been modelled on the foot on tiptoes on pages 158–161. It is a difficult pose to master.

# index

Adobe Photoshop **18**
age and the foot **144–145**

babies' feet **144**
babies' hands **25**
ball, holding a **58–65**
baseball glove, hand in **120–121**
basic feet **146–149**
 flexed **150–153**
 heel down **162–165**
 side view **154–157**
 tiptoes **158–161**
 walking **166–169**
basic hands
 fingers splayed **42–45**
 palm down **26–33**
 palm up **34–37**
 side view **38–41**
bones, finger **20, 22**
bone structure
 hands **20–23**
 feet **142–143**
book, holding a **46–49**
bottle, holding a **54–57**
bowl, holding a **70–73**

carpals **20**
cartridges, ink **14**
characteristics **6–7**

cheeks, hands on **110–113**
child's foot **144**
child's hand **128–133**
colouring equipment **15**
comic-strip stories **6, 18–19**
computer, using a **18–19**

door, opening a **86–89**
drawing aids **13**

equipment **10–19**

face in hands, **114–117**
faces, manga **7**
feet, drawing
 flexed **150–153**
 flip-flops **172–175**
 formal shoe **180–183**
 heel down **162–165**
 military style boot **184–187**
 side view **154–157**
 tiptoes **158–161**
 trainers **176–179**
 walking **166–169**
feet, manga **8–9**
 age **144–145**
 bare **144–171**
 bone structure **142–143**
 finger bones **20, 22–23**

## HANDS & FEET

finger, pointing a **82–85, 134–135**
fingers splayed **42–45, 130–131**
fist, making a **78–81**
flexed foot **150–153**
flip-flops **172–175**
flower, holding a **66–69**
footwear **9, 172–189**

glove
 baseball **120–121**
 black, long **122–123**
 hand in **118–119**
gouache **15**

hair, manga **7**
hands
 age **25–27**
 bone structure **20–21**
 manga **8–9**
hands, drawing
 ball, holding a **58–65**
 book, holding a **46–49**
 bottle, holding a **54–57**
 bowl, holding a **70–73**
 child's hand **128–133**
 clenched **136–137**
 face in hands **114–117**
 fingers splayed **42–45**

 fist, making a **78–81**
 flower, holding a **66–69**
 glove, in a **118–123**
 jewellery, with **124–127**
 mecha hands **134–137**
 okay gesture **98–101**
 on cheeks **110–113**
 opening a door **86–89**
 palm down **26–33**
 palm up **34–37**
 pen, holding a **50–53**
 pointing a finger **82–85, 134–135**
 prayer, in **106–109**
 scissors, using **90–93**
 side view **38–41**
 sword, holding a **74–77**
 thumb's up **94–97**
 victory sign **102–105**
hands in gloves **118–123**
hands in prayer **106–109**
hands on cheeks **110–113**
hand with jewellery **124–127**
holding a ball **58–65**
holding a book **46–49**
holding a bottle **54–57**
holding a bowl **70–73**
holding a flower **66–69**
holding a pen **50–53**

▶▶

# index

holding a sword **74–77**

inks and inking **14**

Japan **6**
jewellery, hand with **124–127**

knuckles **20, 24, 25**

making a fist **78–81**
marker pens **15**
mecha hands **9**
 clenched **136–137**
 pointing a finger **134–135**
metacarpals (*see knuckles*)
military style boot **184–187**

okay gesture **98–101**
old people's feet **145**
old people's hands **25**
opening a door **86–89**

palm down, hand **26–33**
palm up, hand **34–37**
papers **16–17**
pencils **12**
pen holders **14**
pen, holding a **50–53**
phalanges (*see fingers*)

pointing a finger **82–85**
prayer, hands in **106–109**

scissors, using **90–93**
shoe, formal **180–183**
side view of the hand **38–41**
side view of the foot **154–157**
sketchbooks **16**
sketching **16**
sword, holding a **74–-77**

thumb bones **20, 22**
thumb's up **94–97**
tiptoes, standing on **158–161**
trainers **176–179**

using scissors **90–93**

victory sign **102–105**

walking **166–169**
watercolour paper **16**
watercolours **15**
women's feet **145**
women's hands **24**
wrist bones **20, 24**